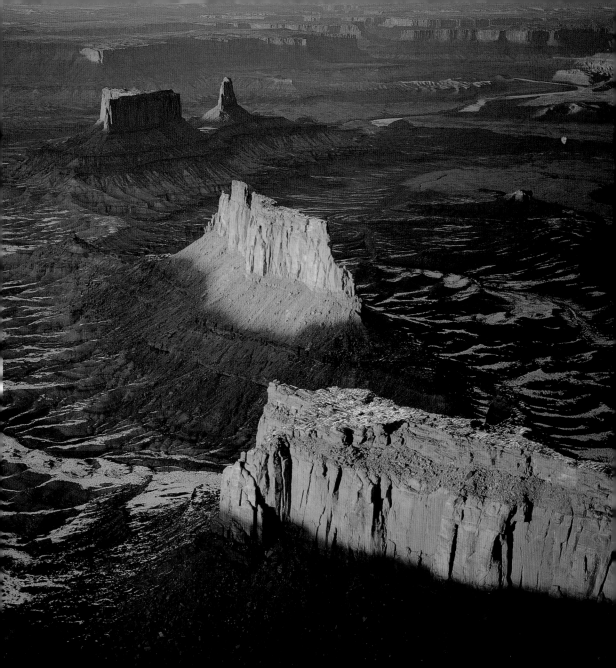

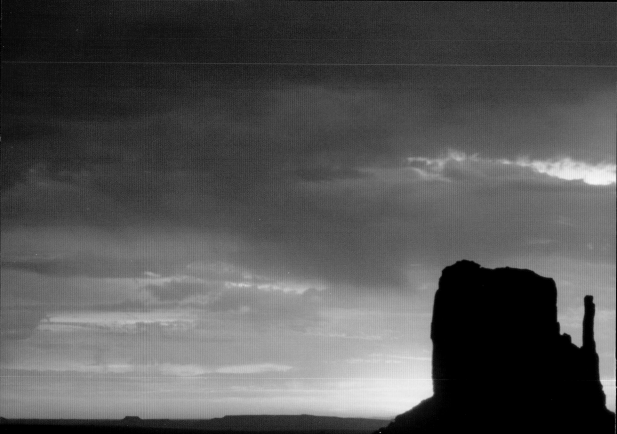

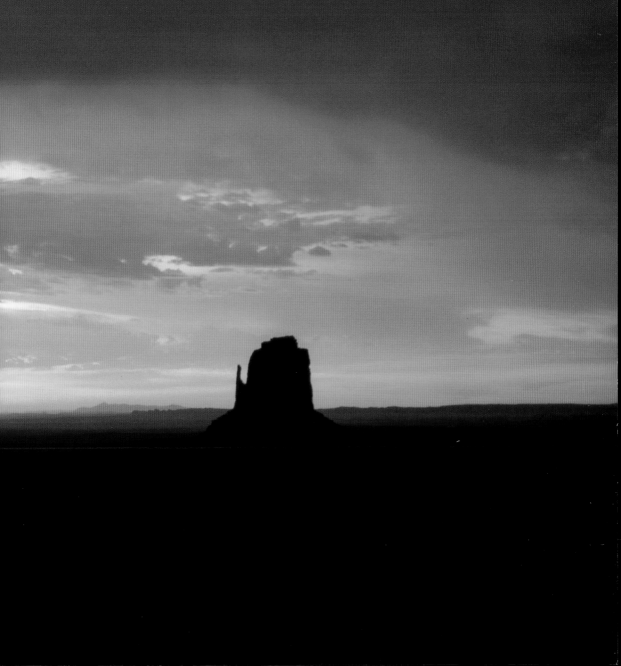

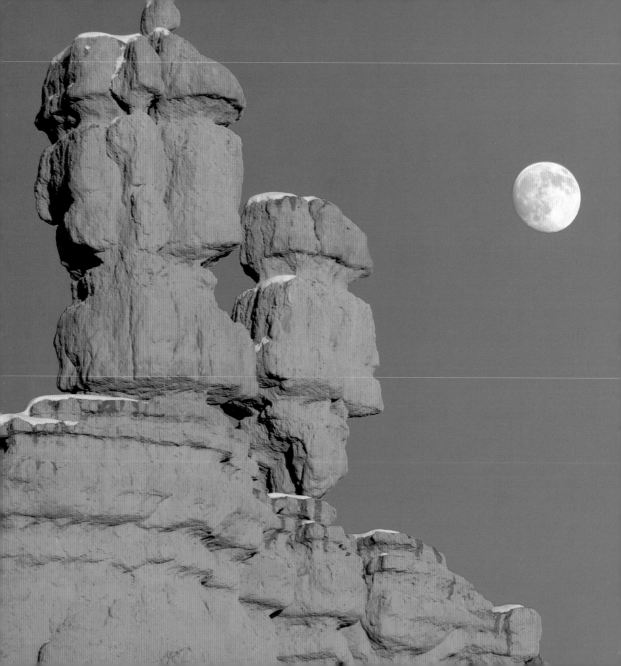

UTAH
SLICKROCK
COUNTRY

Photography by Tom Till
With Selected Prose & Poetry

Utah Littlebooks

Westcliffe Publishers, Inc., Englewood, Colorado

First frontispiece: Maze Buttes, Canyonlands National Park
Second frontispiece: The Mittens, Monument Valley Tribal Park
Third frontispiece: Moon and pinnacles, Red Canyon
Opposite: Patterns in sandstone, Kanab

International Standard Book Number: 1-56579-142-8
Library of Congress Catalog Number: 95-62427
Copyright Tom Till, 1996. All rights reserved.
Published by Westcliffe Publishers, Inc.
2650 South Zuni Street, Englewood, Colorado 80110
Publisher, John Fielder; Editor, Suzanne Venino; Designer, Amy Duenkel
Printed in Hong Kong by Palace Press

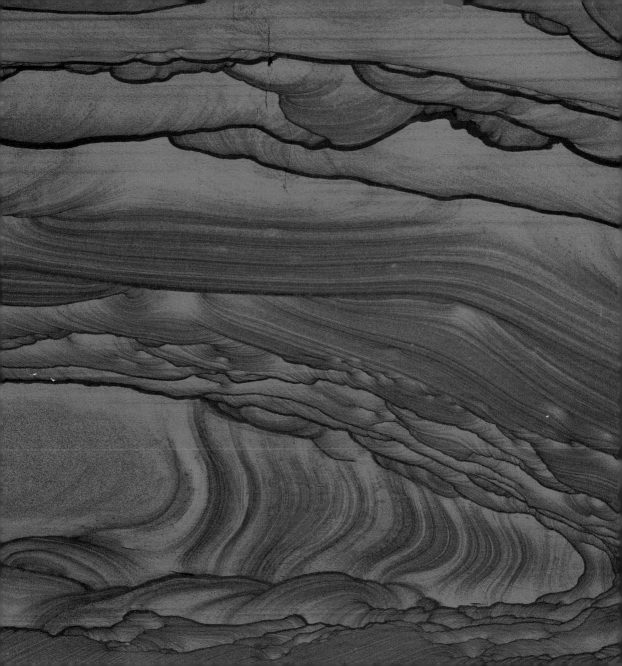

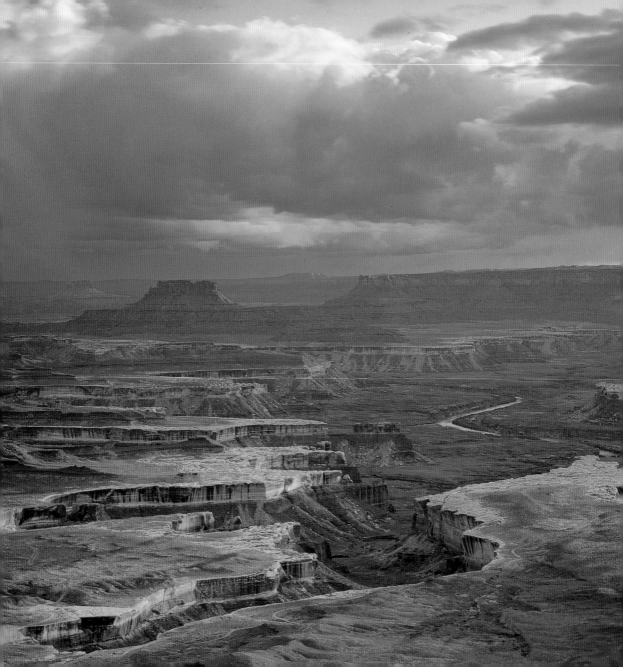

PREFACE

"Slickrock" has always been used among locals of southern Utah to describe rough and rocky areas, while recently it has become well-known due to the famous slickrock bike trail near Moab. I define slickrock as a place where when it rains, more raindrops hit solid sandstone than they do soil or sand. The term may be used to describe parts of Colorado, New Mexico, and Arizona, although the largest expanse of slickrock lies within Utah.

As a young man, I made a mental pledge to spend my youth exploring as much of the Colorado River and its canyons as I could. At the time, I didn't have an inkling of the immensity of the task.

One of the first things I did upon moving to Moab in 1975 was to climb to the top of several of the La Sal Mountain peaks to view the surrounding grandeur. One of the peaks was even named Grand View Peak, and it was from there that I first saw panoramic views of this big, wild country. In those days, before river running and jeeping became popular, and long before mountain bikes came on the scene, the utter desolation of so much beautifully sculpted earth was lonely and sweet beyond description.

I sometimes spent whole afternoons learning the landmarks below me or memorizing the lay of the land. As late afternoon storms marched across the slickrock, I first began to think about capturing this ever-changing scene on film.

A short time later, I tagged along on a scenic flight over canyon country that I have never forgotten. On a three-hour survey of southern Utah, we passed over all the great parks. From the plane, I began to see the bigger picture, and I was staggered by what I saw. There were tens of thousands of canyons, countless buttes, innumerable mesas and minarets, and hectares of fins and hoodoos.

In the heart of it all was the river, where I focused my next explorations. By the time I had decided to photograph the canyonlands, and had amassed a great deal of heavy equipment, I considered how I could transport my cameras easily through this forbidding wilderness. Without any knowledge of running rivers or boating, I bought a raft in the hopes of let-

Sunset from Green River Overlook, Canyonlands National Park

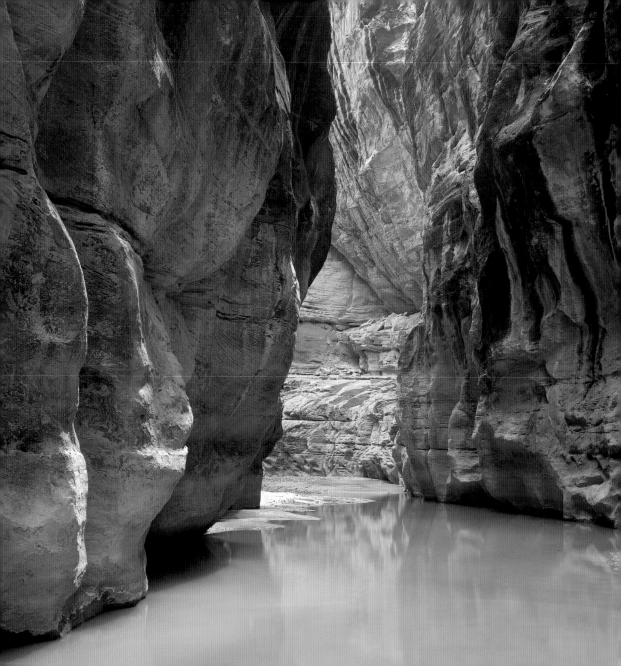

ting the river do all the work. I was soon exploring the San Juan and Green rivers and wandering through Westwater and Cataract Canyons on the Colorado.

My many years on the Colorado River and its tributaries helped formulate my photographic style, and the experience I gained helped me to solve many of the difficult problems encountered photographing in the deep, dark gorges of canyon country.

Although I now travel frequently throughout the world, I still photograph as much as possible at home, rambling around with my camera, snooping for an interesting subject or that special light. Neither is too difficult to find in the canyons of southern Utah.

Unfortunately, all the places depicted in this book are increasingly at risk, as can be seen by any visitor to southern Utah or read about in *High Country News* or the *Salt Lake Tribune*. Moab has become a glaring example of a town discovered and now overrun by recreationists and the lifestyle infrastructure that accompanies them. It's my hope that my photographs will remind everyone of the beauty that still exists in this fragile land, and to inspire

visitors to appreciate the slickrock canyons, mesas, mountains, and rivers not just as backdrops for their fun, but as places to regard with reverence and awe.

It is also my hope that if you've spent time in the slickrock country, you'll lift up your voice or use your resources to help save it. I've always felt, and feel more so now, that all visitors to southern Utah — before jumping on a mountain bike, climbing into a jeep, or even trotting down a hiking trail — should be required to read *Desert Solitaire*, Edward Abbey's classic account of his days as a park ranger in slickrock country. And all of us who have been in southern Utah for a time, should read the book again.

It would be a small price of initiation into this unparalleled place, where as Abbey says, "You will yet find the elemental freedom to breathe deep of unpoisoned air, to experiment with solitude and stillness, to gaze through a hundred miles of untrammeled atmosphere, across redrock canyons, beyond blue mesas, toward the snow-covered peaks of the most distant mountains...."

— Tom Till
Moab, Utah

The Upper Black Box, San Rafael River

"In my case it was love at first sight.
This desert, all deserts, any desert.
No matter where my head and feet may go,
my heart and my entrails stay behind,
here on the clean, true, comfortable rock,
under the black sun of God's forsaken country."

Edward Abbey, *The Journey Home*

Indian paintbrush, Spanish Valley

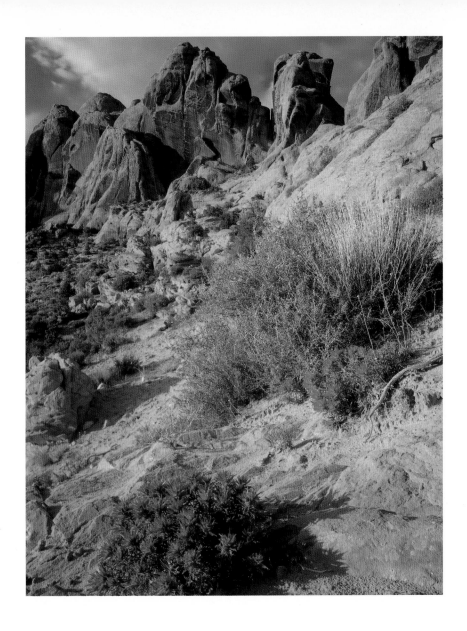

"In anything at all, perfection is finally attained not when there is no longer anything to add, but when there is no longer anything to take away."

Antoine de Saint-Exupery, *Wind, Sand and Stars*

Rainbow Bridge, Rainbow Bridge National Monument

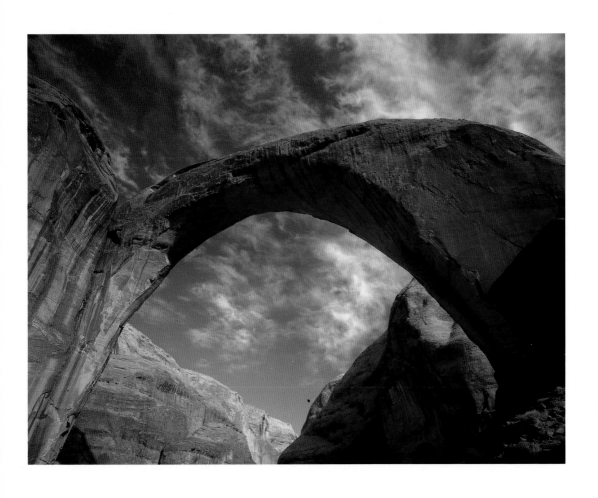

"Wilderness so godful, cosmic, primeval
bestows a new sense of earth's beauty and size."

John Muir, *Steep Trails*

Desert holly, Dirty Devil Wilderness Study Area

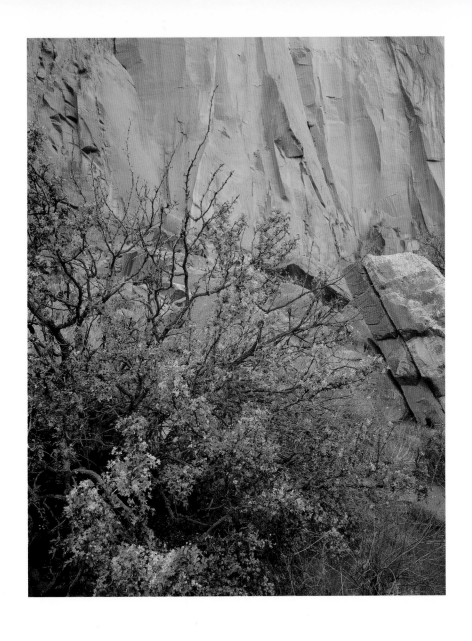

"We are the Ancients of the earth,
And in the morning of the times."

Alfred Lord Tennyson, *The Day-Dream: Envoi*

Anasazi structure, Behind the Rocks Wilderness Study Area

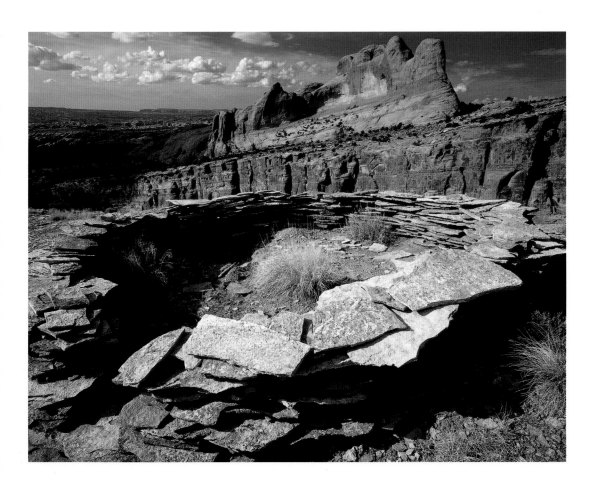

"Is there any reason, out here, for any name? These huge
walls and giant towers and vast mazy avenues of stone
resist attempts at verbal reduction....
The world is big and it is incomprehensible."

Edward Abbey, *Down the River*

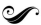

Washerwoman Spire, Canyonlands National Park

Overleaf: Dead Horse Point State Park, looking toward Canyonlands

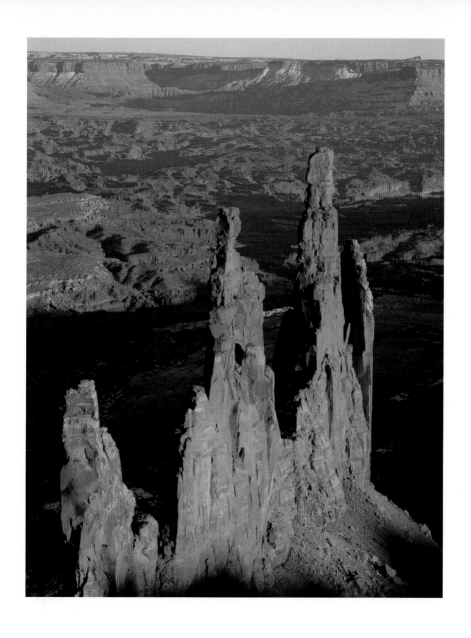

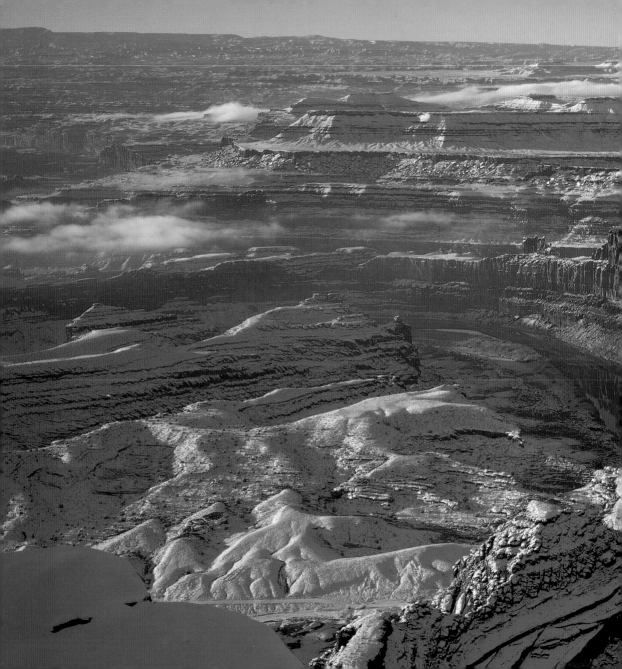

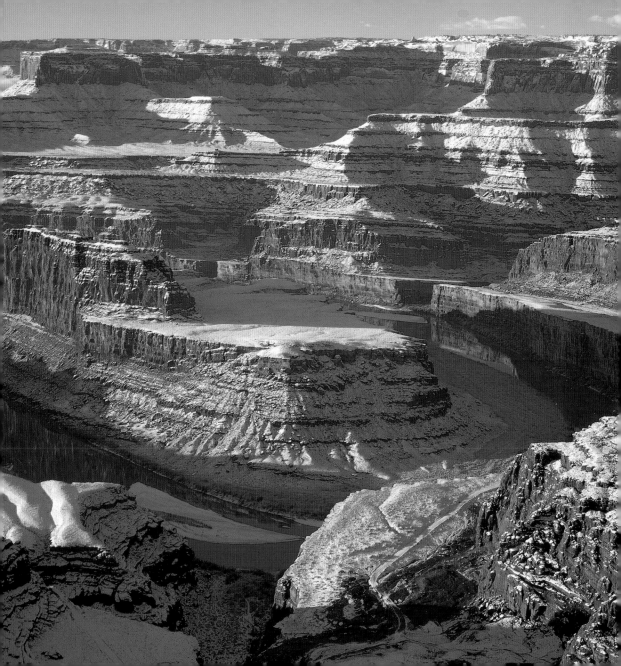

"All nature is but art, unknown to thee;
All chance, direction, which thou canst not see;
All discord, harmony not understood;
All partial evil, universal good."

Alexander Pope, *An Essay on Man*

Rime ice on yucca, Manti-La Sal National Forest

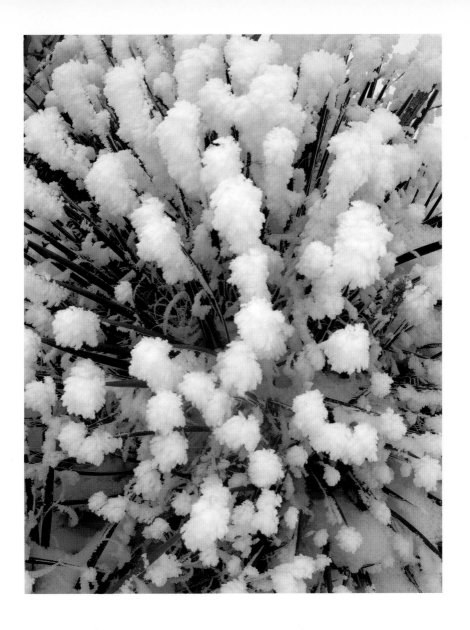

"The point of it all is Out There, a little
beyond that last rise you can just barely see,
hazy and purple on the sky."

Terry and Renny Russell, *On the Loose*

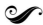

Fisher Mesa at sunset, seen from Top of the World

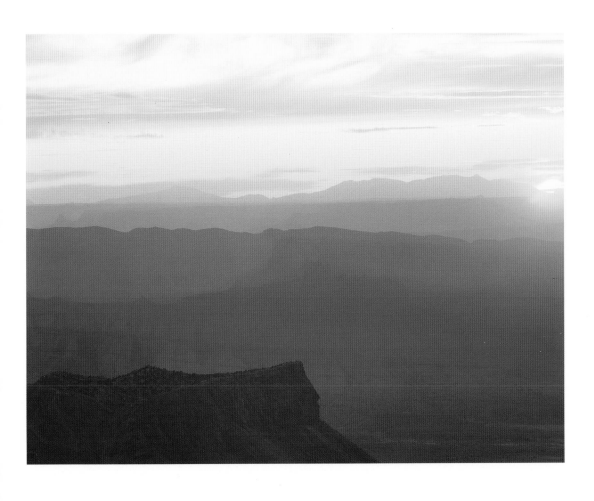

"What is harder than rock,

or softer than water?

Yet soft water hollows out hard rock.

Persevere."

Ovid, *Ars Amatoria*

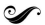

Spring seep, along the Escalante River,
Glen Canyon National Recreational Area

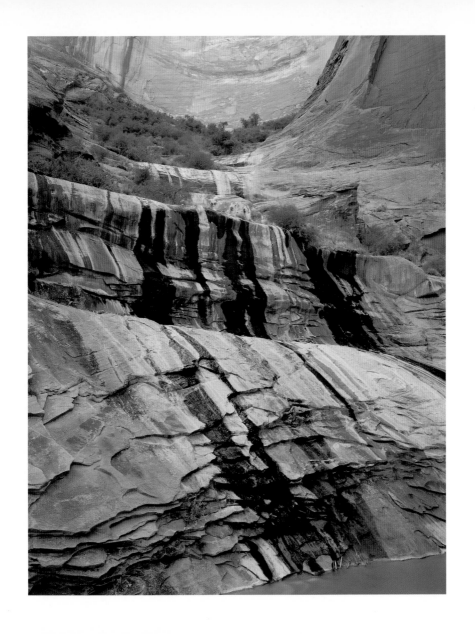

"Every flower...carries with it the impress of its maker, and can...read us lectures of ethics or divinity."

Sir Thomas Pope Blount, *A Natural History*

Datura blossoms, Cottonwood Canyon

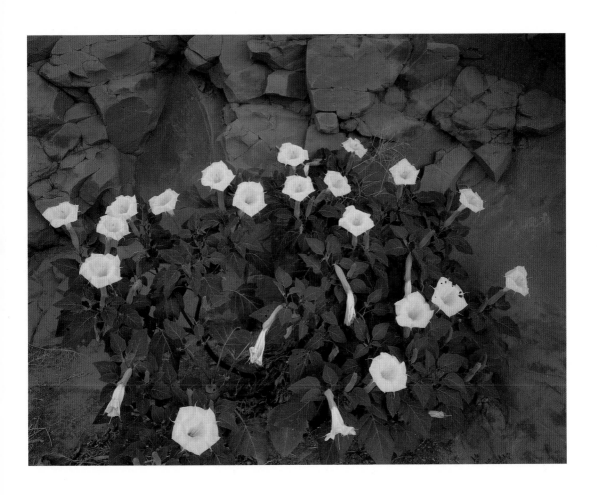

"Elsewhere the sky is the roof of the world; but here the earth was the floor of the sky."

Willa Cather, *Death Comes for the Archbishop*

Delicate Arch, Arches National Park

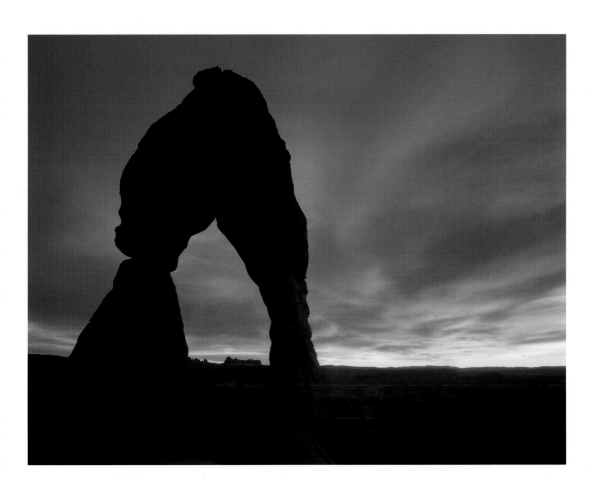

"We shall not cease from exploration

And the end of all our exploring

Will be to arrive where we started

And know the place for the first time."

T.S. Eliot, *Four Quartets*

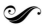

Petroglyphs, Dark Canyon Wilderness

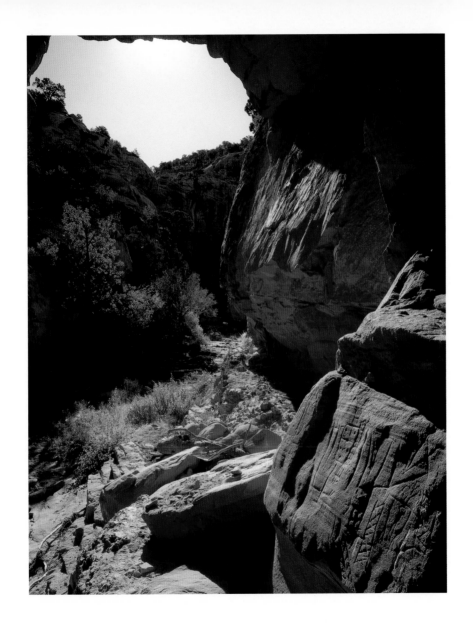

"In Nature's infinite book of secrecy,
A little I can read."

William Shakespeare, *Antony and Cleopatra*

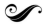

Aerial view of snow patterns, San Rafael Swell

Overleaf: Landscape Arch, Arches National Park

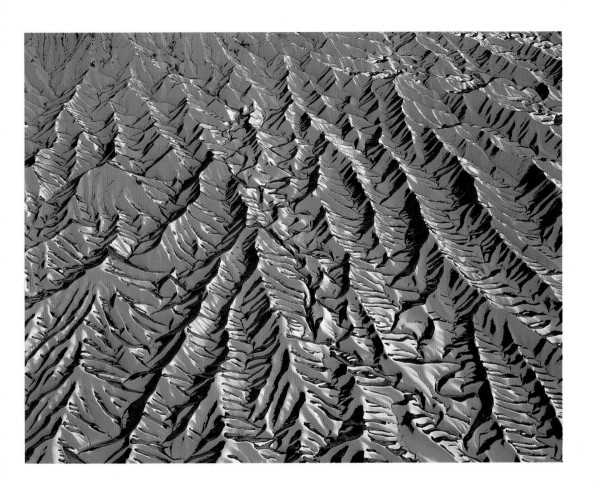

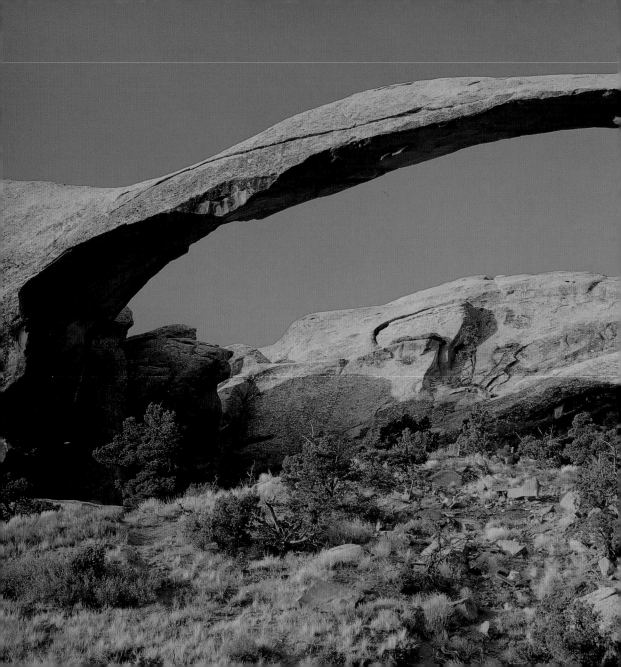

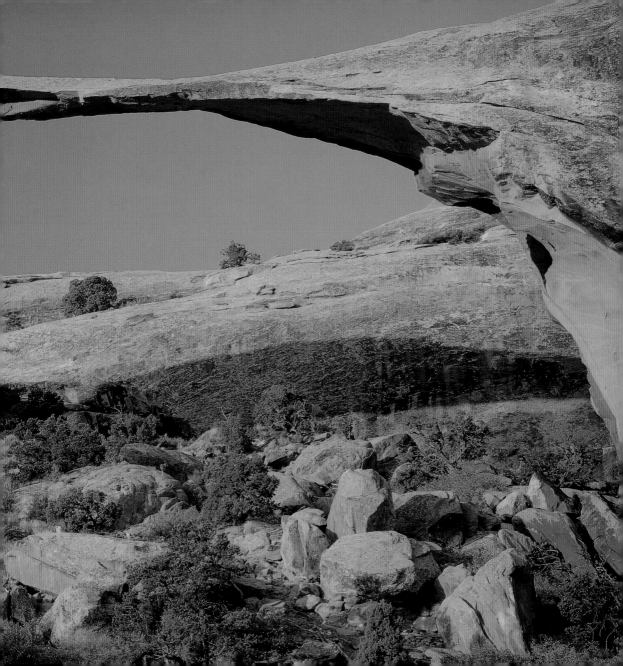

"The finest workers in stone are not copper or steel tools,
but the gentle touches of air and water
working at their leisure with a liberal allowance of time."

Henry David Thoreau, *A Week on the Concord and Merrimack Rivers*

Sandstone narrows, Kane Creek, near Moab

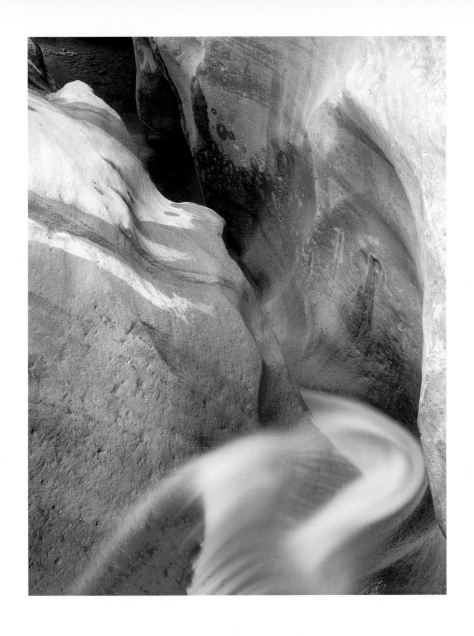

"Time is a gentle deity."

Sophocles, *Electra*

Petroglyphs, Dark Canyon Wilderness

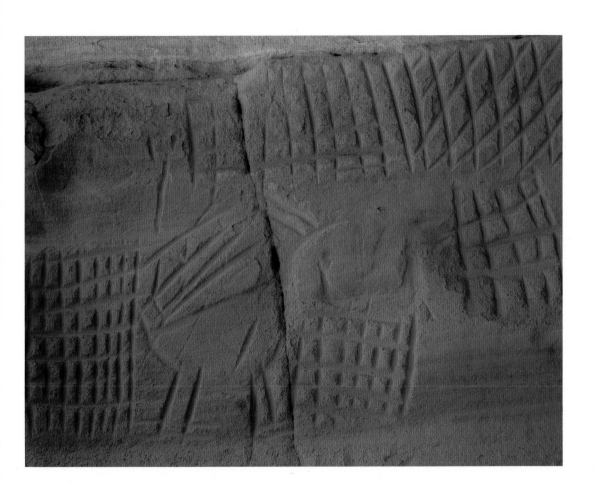

"Who so leave the civile society to place himself in some solitarie desert, taketh as it were the form of a beast, and in a certain manner put upon himself a brutish nature."

Stefano Guazzo, *Civile Conversation*

Bottleneck Peak, Sids Mountain Wilderness Study Area

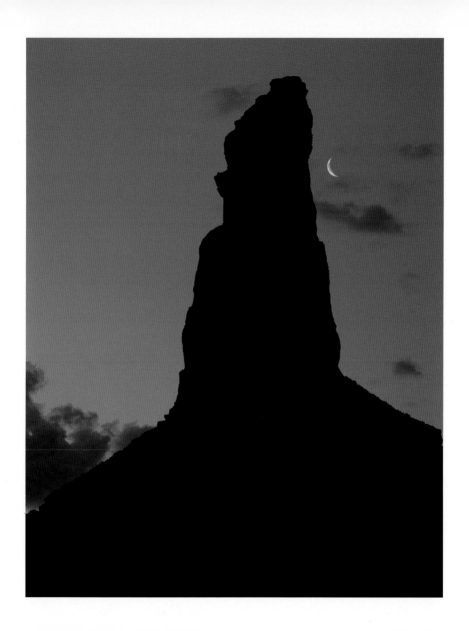

"But at my back I always hear
Time's winged chariot hurrying near;
And yonder all before us lie
Deserts of vast eternity."

Andrew Marvell, *To His Coy Mistress*

Anasazi ruins, Edge of the Cedars State Park

"On this side there is a chain of high mountains,
and from the top to the middle they are of white earth
and from the middle to the foot they are uniformly striped
with yellow, white and not very bright red ochre."

Father Silvestse Velez de Escalante, *Journal*

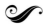

Weathered bristlecone pine, Dixie National Forest

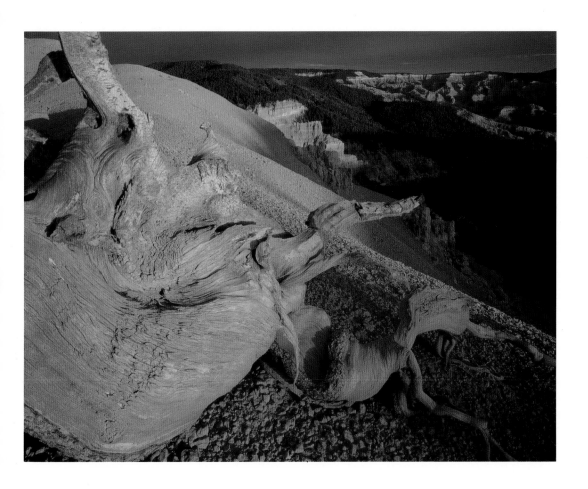

"Wonder grows where knowledge fails."

Tacitus, *Agricola*

Angel Arch and Molar Rock,
Canyonlands National Park

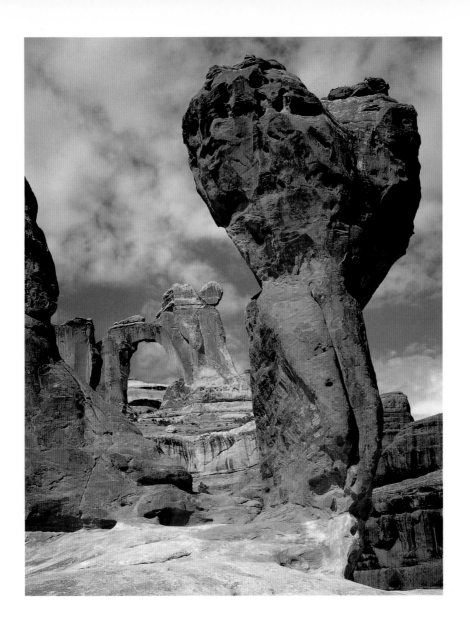

"Surely there is something in the unruffled calm of nature that overawes our little anxieties and doubts; the sight of the deep-blue sky...seems to impart a quiet to the mind."

Jonathan Edwards, *The New Dictionary of Thoughts*

Autumn cottonwoods, Arches National Park

Overleaf: The Colorado River, near Arches National Park

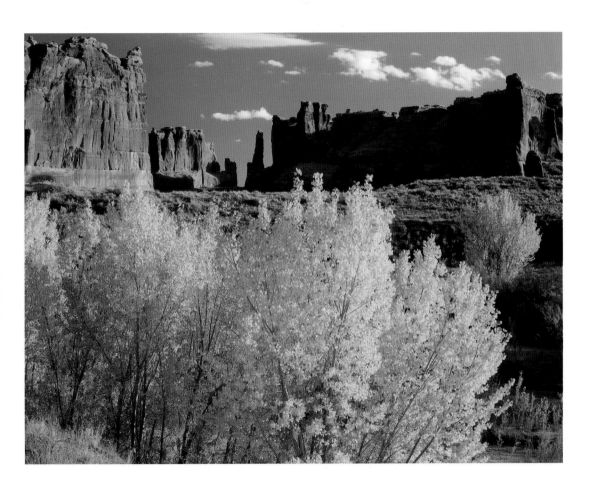

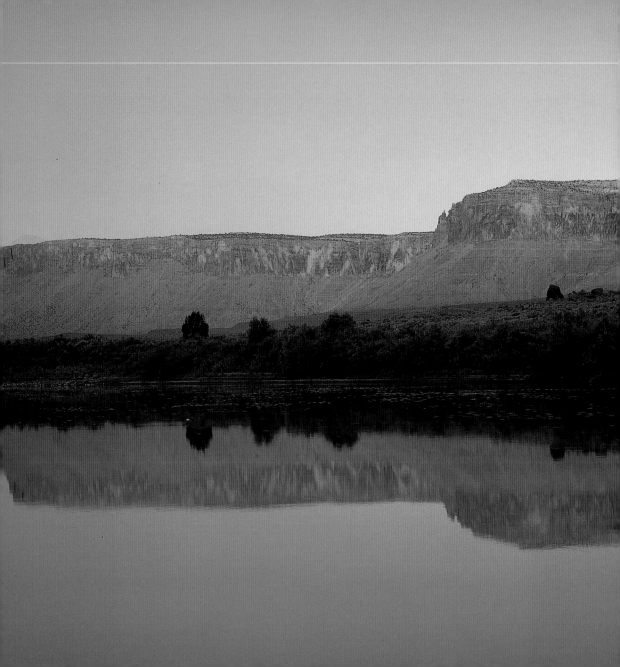

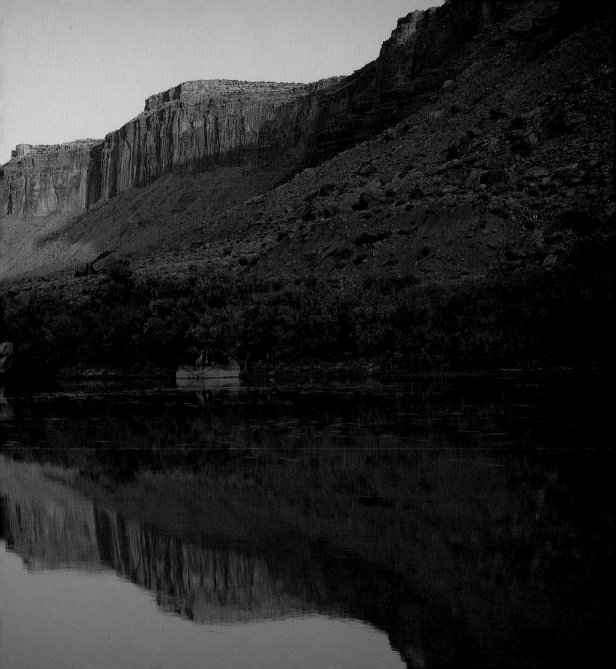

"The main body of the flood now appeared around the bend up canyon. Magnificent spectacle.... the ground was perfectly dry. But you could feel it tremble with the resonance of the flood."

Edward Abbey, *Slickrock*

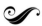

Slot canyon, Pariah-Hackberry Wilderness Study Area

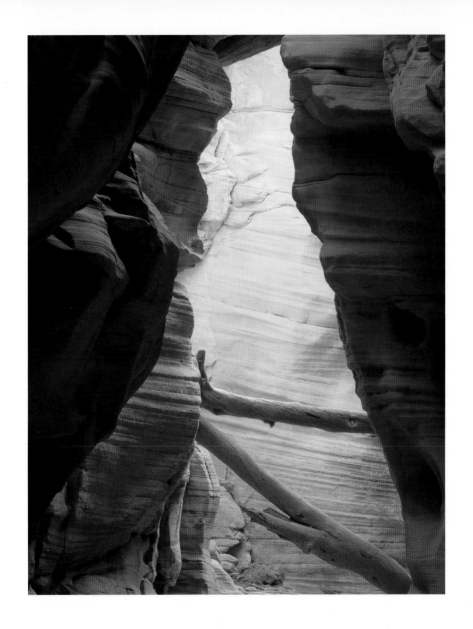

"Nature in a new mood — she is dreaming of canyons..."

John Burroughs, *Time and Change*

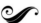

Rainbow and red rocks, Dead Horse Point State Park

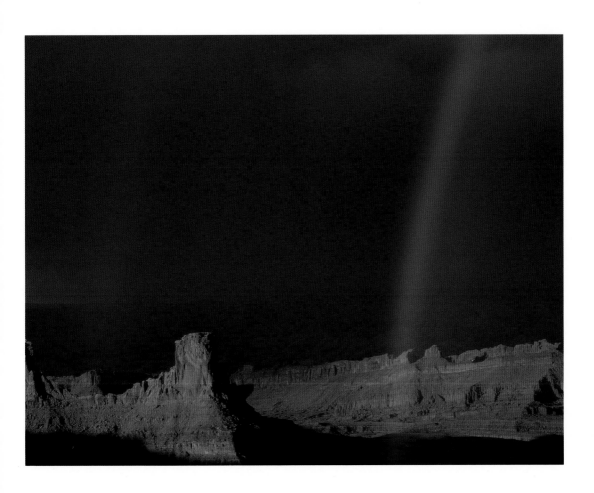

"Everybody needs beauty…places to play in and pray in where Nature may heal and cheer and give strength to the body and soul alike."

John Muir, *Travels in Alaska*

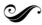

Mule's ear flowers beneath Courthouse Towers,
Arches National Park

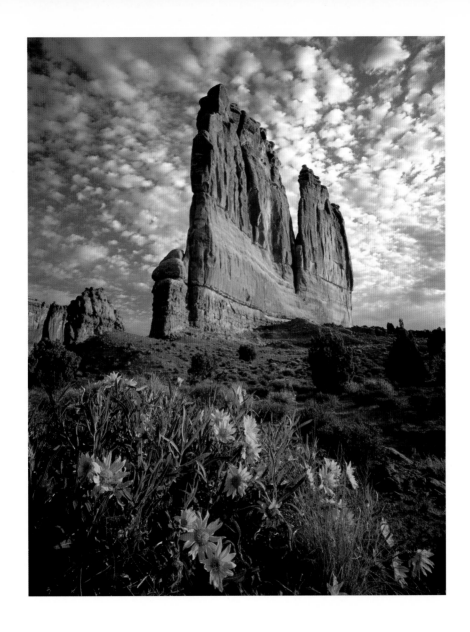

"The sight of such a monument is like a
continuous and stationary music."

Madame de Staël, *Corinne*

Hovenweep Castle, Hovenweep National Monument